FORTY NAMES

Parwana Fayyaz was born in Kabul, Afghanistan, in 1990. From the age of seven to sixteen, she was raised in Quetta, Pakistan. Once her family was able to return to Kabul, she finished high school and enrolled in her first English program in Chittagong, Bangladesh, where she also began her undergraduate studies. In 2012, she transferred to Stanford, where she earned a BA, with a major in Comparative Literature and a minor in Creative Writing, and an MA in Religious Studies. In 2016, she moved to Trinity College, Cambridge, to pursue a PhD in Persian Studies. She defended her thesis in 2020 and became a Research Fellow at Peterhouse, Cambridge, where she continues to do both her academic and creative work.

FORTY NAMES

Parwana Fayyaz

CARCANET POETRY

First published in Great Britain in 2021 by
Carcanet
Alliance House, 30 Cross Street
Manchester, M2 7AQ
www.carcanet.co.uk

A CIP catalogue record for this book is
available from the British Library.

ISBN 978 1 80017 107 7

Book design by Andrew Latimer
Printed in Great Britain by SRP Ltd, Exeter, Devon

The publisher acknowledges financial
assistance from Arts Council England.

CONTENTS

Roqeeya

Patience Flower to Morning Dew

Forty Names

ROQEEYA

SEWING NEEDLES

When the war started, my father took my mother on a journey,
a journey unwanted by either of them –
away from home and far from their city.

Into exile, next to our little feet and hands,
my mother carried her box of sewing needles,
and her *Butterfly* sewing machine made in the USSR.

Moving between rented rooms, fabric became a land familiar to her.
Opening her box and resting her sewing machine on the floor,
she made dresses of different colors and textures.

Kabul gave her velvet, in all colors –
she chose the colors of liver and ocean,
 burgundy and royal blue.

Pakistan gave her satin, in yellow and orange,
she preferred something
 onion-colored.

India gave her cotton, in thick and thin,
she selected something
 in between.

One year, she learned to spin coarse wool.
And with the money she earned,
 she bought silk.

She waited. I waited.
Until the hard skin on the tips of her fingers softened,
before she touched the silk.

She then made dresses for her three daughters,
Parwana, Shabnam, and Gohar, in colors
 pistachio, red-rose, and sea-green.

Every stitch of her needle gave life
to elegant styles of youth and an Afghan
 mother's pride, even in exile.

THREE DOLLS

During the wars,
my mother made our clothes
and our toys.

For her three daughters,
she made dresses, and once
she made us each a doll.

Their figures were made with sticks
gathered from our neighbor's garden.
She rolled white cotton fabric
around the stick frames
to create a skin for each doll.

Then she fattened the skin
with cotton extracted from an old pillow.
With black and red yarns bought from
uncle Farid's store, my mother created faces.
A unique face for each doll.

Large black eyes, thick eyelashes and eyebrows.
Long black hair, a smudge of black for each nose.
And lips in red.
Our dolls came alive,
with each stitch of my mother's sewing needle.

We dyed their cheeks with red rose-petals,
and fashioned skirts from bits of fabric,
from my mother's sewing basket.
And finally, we named our dolls.

Mine with a skirt of royal green was the oldest and tallest,
and I called her Duur. *Pearl.*
Shabnam chose a skirt of bright yellow
and called her doll, Pari. *Angel.*
And our youngest sister, Gohar, chose deep blue fabric,
and named her doll, Raang. *Color.*

They lived longer than our childhoods.

BRIGHT DREAMS

When I was ten, my mother made me a dress.
The blouse was in yellow –
the skirt membered in colors and distinct textures.

The pieces in tangent edged my waist.
Stitched together with one thread. Emanating rivers of color –
flowing toward the ground.

The skirt danced around my legs,
stirred by the wind.
I felt beautiful wearing it.

The dress became a symbol of a nomad –
an Afghan refugee girl,
with homeless parents.

The wanderers.
Thought the other mothers and daughters
in their mono-colored dresses.

For me the dress represented my mother's skill.
Only she could make something so beautiful from the remnants of fabric
brought from Kabul.

The green and purple,
velvet in texture, subdued in color
 stitched side by side with yellow in between.

The red and blue,
satin in texture, vibrant in color,
 stitched side by side with orange on either side.

And in between
the pistachio and pink silk, she
 stitched black, to not disrupt the eye.

I wore my mother's art with indefatigable joy.
Like the skirt's colors,
 I was filled with bright dreams.

THE OLD KITCHEN

In the house where we returned after the wars,
the old kitchen was the only remaining building.
We rescued my grandmother's clay tandoor from the dirt.

I spent hours in that kitchen
cooking and cleaning – and, late at night
preparing my school lessons.

'In there, they washed your grandmother's body
and put her in the coffin,' my mother said,
cautioning me not to spend late night hours, alone, in there.

In there, I never felt alone.
The quiet freedom for my mind.
The old walls, my tablet.

To write my favorite Pashto and Dari verses,
work out chemistry and physics formulas, and draw
algebraic and trigonometric shapes.

One day, my mother suggested we paint the walls.
I explained that the walls held lessons,
to remember for my exams.

My mother could not read.
But she understood and left the walls alone.
After I left home, those walls, that kitchen

became a place of solace for her,
from the pain of missing her oldest daughter.
And a palace of memories, for both of us.

THE SCORPION

It was after-the-war-time.
We reclaimed our land,
and hurried to rebuild our home.

But the walls remained unfinished.
That first winter
the family slept in one room to stay warm.

One midnight, we were awakened to look
for a scorpion that my mother saw
crawl across her pregnant belly.

Those days, my mother projected an unusual
sense of happiness, and liked to escape
to strange places.

A few nights ago, she disappeared.
We looked for her under the falling snow,
and found her sitting inside the old kitchen.

Tonight, she was not afraid of the scorpion.
Instead she helped us look for it.
We finally found it among the tangled rug fringes.

My father picked up the creature between its pinchers
and released it into the open night.
My mother whispered, 'you will have a sister.'

Confused, I protested.
'But grandmother says you have a straight back,
so it will be a son, proud and dignified.'

'Only a girl stands strong,
like a mountain, when facing fear.'
My mother responded.

The baby was born in late November,
just past the constellation of Scorpio,
under the Archer – it was a girl.

My mother was correct.
My grandmother was half-correct.
My sister, Shamama, *Sun-glare*, is proud and dignified.

ROQEEYA

My mother's name is *Roqeeya.*
But no one calls her by that name anymore.

She has become *Chaman Grass's daughter, Ali's mother,*
the mother of children, or *Oo wife.*
Fifty-three years have passed.

This evening, seeking solitude,
she climbs three stories toward the sky,
to sit on the rooftop, to quietly sip her tea.

It is a clear Kabul night,
the stars illuminate the sky.
More vibrant than the irises in the garden.

She does not listen to my father, calling
o mother of children.
This is her time.

She ignores the neighbors, who gaze at her
behind their windows.
She quietly sips her tea.

All her life, she looked up at the stars for her children.
Tonight, she looks upward.
These stars are for her.

They hold a thousand dreams,
which glimmer still in her mind.
A song-writer. A singer. A dressmaker. A dress-seller.

'A woman with an idea and a wallet,'
she would say to me, her oldest daughter,
wanting me to be free.

'Be independent. Earn your own money.
Keep your face red and your name green,'
she would say tenderly.

This night, under the stars, she finds freedom.
The stars share her momentary triumph –
as she quietly sips her tea.

PATIENCE FLOWER TO MORNING DEW

He owned two mansions, two barns,
the woman the Khan fell in love with
at first sight.

Her name was Sabar Gul, *Patience Flower.*
She lived with her mother
in a clay hut.

By an oath passed between the elders,
Flower had been engaged to her cousin in her childhood.
Therefore, the Khan could not ask for her.

In a series of dark nights and winter days,
the Khan was driven to *Flower.*
Finally,

the night before she was to be married,
he came on his white horse
to seize *Patience Flower.*

Flower disappeared. A fable spread.

Patience Flower, the daughter
of that deceased nek mard, *good man*
ran away with her Mashuq, *beloved.*

Soon the summer sun was burning
bright on the shimmering wheat-fields,
farms were waiting for fall.

Gradually the rumors spread to other villages.

Soon the Khan was back in the village riding his horse.
All the rumors seemed pleasing.
He thought.

The following dawn, before the women woke to bake
their bread and the shepherds to play their flutes,
Flower was brought back to her village.

She was left leaning, her back
against the wooden door.
Unable to knock, she waited for the door to open.

The Khan, hidden from view, kept watch.
Gazing at *Flower* – and her surroundings –
to protect her from the wild wolves.

The door opened, and the Khan
mounted his white horse
and returned to his mansion.

Patience Flower remained unseen in the village,
for many months. Her mother locked her in, far from
the villagers' sight, their anger, and horror.

*

Sardar *The General* and Pacha *The King* are sisters.
Their looks are alike and stunning.
They are my father's half-sisters, half-aunts to me.

When I met them for the first time, my mother told me,
'if you had seen your grandmother Sabar Gul
you would find so much of her in your aunts Sardar and Pacha.'

Their names suggest something more than disillusioned recognition.
The General runs the big house in the village on her own.
The King speaks up against the Taliban.

The story behind their naming is
one of those unremembered events.
But that story made the very existence of Sardar and Pacha as sisters.

When the Khan abducted Sabar Gul,
he was too sure that the innocent
Flower did not know what he had done to her.

But *Flower* did not take the blame alone.
Her baby took it too.
She was pregnant with Sardar.

In return for the damage done to her family honor
and to stop the killing of *Flower*,
the Khan acknowledged his deed.

He gave all his estates in Shaleela
to *Flower's* oldest brother, Chaman *Grass*.
And in return,

Flower was sent to the Khan's mansion
to become the unmarried second wife
of this man.

In the middle of events folding and unfolding
between a lover and his beloved,
their two daughters were born and named mysteriously.

'Out of love, they were conceived. Out of love,
they were named Sardar and Pacha,'
a few good people say.

Patience Flower's mother cursed the Khan day and night,
until the curse turned into a poison.
And in the winter season, a few years later,

the Khan's body collapsed on the ground
beside his white horse. After twelve days on his bed,
the Khan died young and handsome.

Young and beautiful with her two daughters,
Sardar and Pacha – *Patience Flower* was married by her brother
to a man who beat her.

As the years passed, *Flower's* patience and calm
were admired by all, except
perhaps her husband.

She became a wise healer.
She rode out from her home to administer to the sick.
Across wheat-fields, she dressed all in white.

'She held her two daughters close to her chest
as she rode from one village to another, on the same white horse
that Khan rode on the abduction night.'

Here my mother's story ends.
My mother, who is the daughter of *Grass*,
and niece and daughter-in-law to *Patience Flower*.

*

I never met my grandmother.
She died before I was born.
But sometimes I ask about her.

And my mother says,
'your younger sister Shabnam *Morning Dew*
looks exactly like your grandmother, *Flower.*'

And my father cries,
when he witnesses the serenity and kindness
of his beloved mother

in his daughter.
That has come down from one woman to another.
Patience Flower to *Morning-Dew.*

In the middle of the night,
I write a letter to Bibi Gul and Taj Begum imagining their day-trip.
Measuring the hours with the gesture of the sun,
as they crossed the muddy valleys –

with a hope that someone will help on the other side,
offering them shelter to rest for the night.
I first heard the story about these women fleeing
and losing their way in crossing the valleys –

to an end uninvited.
The reason for their flight remains a mystery,
and never to be remembered again.
The remaining people call their flight

an escape out of the village
in search of some distant land.
Abhorrence translates the word on the tip of their tongues.
Among those women were my two

great aunts, Bibi Gul *Lady Flower* and Taj Begum *Madam Crown* –
whom I did not know until one day I heard
my grandfather Chaman *Grass* curse them under his breath:
'Oh the creators of this twirling restless pain in my chest… Jankan Jankan.'

In his soulless echoes,
he named them Siya Ru *the Dishonored*.
His pain grew deeper after his sisters were captured mid-way to the valley
and were brought back and scorned by a hundred village men.

Later those women were sealed in the city-prison for disloyalty.
Women without men became pregnant in the prison –
giving birth to illicit children.
No names. No stories.

No past to be remembered.
Their children grew into complete human beings,
scorning themselves for their anonymous fathers
and dishonored mothers, who remained unknown to us.

The village-men may never recall their return,
or may never tell the truth about
their lives in the harshness of village-life,
so ready to chase away the white wolves of winter.

Here I measure time in the motion of my feet
crossing the oceans, to write their names,
and to find the knot that binds me to *Flower* and *Crown's* souls –
to give them names so they can rest for the night during their next escape.

AUNT *QUIETUDE*'S JOURNEY

My Aunt Sakina, *Quietude*,
was born to *Patience Flower* and her second husband,
Treasurer, in a small village in Ghanzi.

As a young girl, *Quietude* was home-schooled
under *Treasurer*'s supervision.
She became, after her education,
'a girl with fire and river'.

She became as free in speaking her mind,
as any human should be.
But whispers circulated in the village.

Her girlhood was taken from her.
She was not even thirteen at the time.

Sent to Turkistan, to the unknown
mountainous and tribal region
of cold weather and wild people, with a man
who was thought to have touched her hands one night.

My maternal grandmother *Lion* and my mother
told me *Quietude*'s father truly loved
and admired his daughter, and he always wanted
her to be well-educated and to go to Kabul
for her studies.

'Alas bad-bakhati, *evil-fate* fell upon her...'

My father always regretted
his sister's talents were wasted.

She was the fairest, the most educated,
and now the youngest wife of her husband.

Later on, in our extended family, my Aunt *Quietude*
became a lesson to be learned by girls growing up.
She was an example of a woman,
who became miserable,
because of her own mistakes.

No one wanted their daughter to be
as free as *Quietude* once was,
because that daughter might end up
going to Turkistan.

*

I was brought up this way.
If I or any of my sisters did not study well,
we were gently threatened with being
sent out to Turkistoooo.

My father never mentioned his sister in this way.
For him, his sister was an image,
a woman with a beautiful mind,

dark eyes, and high cheekbones.
The smartest girl in the village and the young girl
who vanished before he was four.

He never met his sister again.
He met her husband,
whenever the husband visited Kabul.

Her husband always brought
good messages of how *Quietude* was the bravest
and strongest woman in the village.

By then they had two sons.
Quietude took care of her husband's poppy fields,
which provided opium for the northern regions and beyond.

My aunt was described like an ox
working in the fields, day and night.
Her husband said she looked 'healthy in her bones.'
That was a compliment for a woman.

<div align="center">*</div>

People were amazed when Aunt *Quietude*
and her husband's entire family went
to Iran as refugees during the Soviet period.

She learned to live the life of an Afghan refugee in Iran.
She studied the Quran,
and gave the most tearful sermons at the women's
gatherings during religious festivals.

Her neighbors in Iran
called Aunt *Quietude* a moral and spiritual woman
with imperial blood.
Her nickname became Bibi – *a holy woman* of prophetic descent.

In exile, she bore three daughters,
Perfect Woman, Innocent Woman, and *Emigrant Woman.*
Innocent and *Emigrant* were like daffodils in Aunt *Quietude*'s garden,
but *Perfect Woman* was the iris.

Perfect Woman was smart and poetic.
Aunt *Quietude* sent *Perfect Woman* to school,
and educated her in all kinds of household tasks.

She taught her to make her own choices,
and to use her language with diligence and kindness.
'*Quietude* is a good mother,'
my mother often said.

<center>*</center>

During the Taliban period,
my maternal grandfather *Grass* also emigrated
with his family to Iran.

His son, *Beloved* was a boy then
only a few years older than *Perfect Woman*.
Rumor has it – *Perfect Women* fell in love with *Beloved*.

Or *Beloved* fell in love first.
The marriage was arranged
by the elders of both families.

Aunt *Quietude* had a difficult time
sending *Perfect Woman* off to
my maternal grandparents' home, a bride.

Grandfather *Grass*' unforgiving reaction to
to the fates of his two oldest sisters, *Lady Flower* and *Madam Crown*, and
his undying resentment toward his third sister *Patience Flower*
were common knowledge across lands and time.

And his reluctance to acknowledge the existence
of his surviving eight daughters and eight granddaughters
had not gone unnoticed.

How could he then like and appreciate *Perfect Woman* –
this most educated and skillful woman,
who was now becoming part of his family?

Finding solace in the situation
Aunt *Quietude* took the sign of love between
Perfect Woman and *Beloved* to be a divine intervention.

Unlike her own fate, she believed
God would be with *Perfect Woman*.

THE PERFECT WOMAN

Sediqa, *Perfect Woman*, is my father's niece,
the eldest daughter of Aunt Sakina, *Quietude*.

Perfect Woman was born in Mashhad, Iran.
She went to school there.
She wrote prose poetry in Dari,
and knitted beautiful embroidery.

She was well educated and made her own choices.
She was an extraordinarily good cook and gracious host.
She spoke a delicate language
that enchanted all who heard her.

At twenty-one years old,
she married Habib, *Beloved,*
my maternal uncle,
my mother's stepbrother.

But after eight years of marriage,
she had not been able
to give a child to her husband.
People blamed her weight.

My mother always said,
'Sediqa's language is worth
a thousand thin women
with dozens of kids.'

Every woman knew
that *Perfect Woman* loved children.
But, it seemed, she would never
love a child of her own.

*

Perfect Woman has now been
medically determined to be infertile.

My maternal grandfather *Grass*
publicly expressed his regrets
for not having a grandchild
from *Perfect Woman*.

He once told me,
'*Perfect Woman* is a good-natured woman,
she just needs a child
to be *a complete woman*.'

He blamed *Perfect Woman*
for not being able to have a child.

And my Uncle *Beloved*
was now determined to have his own children

*

Tonight, we are at my grandfather's home
to the west of Kabul,
to discuss 'an important issue.'

Perfect Woman sits behind
a graying curtain
that restlessly unfolds
with the evening breeze.

In a corner of the room,
my maternal grandmothers *Lion* and *Good Fortune*,
sit with my mother and two of my aunties
discussing matters of the house.

Matters that tonight
are irrelevant, given
it is *Perfect Woman*'s presence
that is of concern.

From an adjacent room,
sounds from the TV
and the voices of men talking
can be heard.

I sit near the door
in the dim light of evening,
watching over my little sisters
playing in the dusty yard.

*

Tradition suggests that a man should marry
another woman to have his own children.

My parents support *Perfect Woman*.
My father refuses to go to the meeting.
He stays at home, knowing
there is no reconciliation possible.

It is almost midnight.
The children are sleeping soundly now.
The women are still talking.
Finally, the men emerge from their room.

A decision has been made,
they announce.

Perfect Woman needs to go to Iran
to get expert medical advice.
Beloved must sell his car
and pay for her trip.

She will be sent to Iran.
If she is sterile, she should not return.
If she is fine, *Beloved* will bring her back
with joy and a celebration.

 *

A week later, *Perfect Woman* said to me:
'I cannot believe they are doing this to me.

I love Habib.
I have always respected him
and his family.
I do not want to go to Iran.'

I say,
'just free him and free yourself.'
At the time, I did not know
what I meant by that.

But I knew, another woman had already been asked
into marriage with *Beloved*.
Her name was
Little Fragrant Flowering Plant.

<center>*</center>

Today, *Beloved* and *Little Fragrant Flowering Plant*
have children of their own.

Fairy-like, Enhancement,
Divine Lady, Darius's General,
Praised One,
and *Brawling Blackguard*.

Each with a unique face and a name,
collectively, the pride of their parents.

But recent news shattered the years of
pride and trust in this second marriage.

Perfect Woman remarried in Iran.
A year ago. She was pregnant with a child of her own.
By now, she must have named her child,
something that aligns with her own perfection.

I do not know the name of her child:
I lost a cousin and a friend
the day she left Kabul for Iran.
But every single day,

I rejoice for *Perfect Woman*'s freedom
from *Beloved* and his family,
who misjudged her womanhood.

GRANDMOTHER LION'S RUBY RING

My grandmother *Lion* wears a deep red ring,
a ruby set into a silver plate.

She lived in the valleys.
An orphan girl, herding her sheep in the fields.
A virgin: not yet menstruating, she became the bride
for another orphan. A ring was given to her
in a man's name; she was taken away.

She became a wife and lived in the city,
caring for the man, his four brothers,
his four sisters and their sad stories.

Seasons passed by, hardships:
she was separated from her husband
and went to live with her three boys and their families.

Throughout her separation,
she had always dreamed about her husband sitting
under the shade of the apricot trees, or watering
tomato plants in the garden – she was Zulaykha
and he Yosuf. She always referred to him
as the prophet in her dreams.

She does not complain about the wounds on her hands.
A mother in law, a grandmother,
and gradually she became
a great-grandmother.
She had never shed a tear over the shattering clay-roofs
under the snowfalls.

Now her story is about an old woman waiting for death.
The ring goes to the one who washes her body.
Only the woman who washes her well, dresses her properly
and pays respect to her body will inherit her ring.

On a dinner sofra *buffet*, girls are grapes
boys are pomegranates

I remember when I was a loving wife
your grandfather was as handsome as Joseph
I dream of him –
he wears his white shirt –
young as the new apple blossoms

he calls for me
I am outside, the glow of the morning sunshine, the breeze –
I pick the last fresh tomatoes from the garden. I hear him calling me
I run toward him and see his handsome face...

A break in the conversation –
what was I saying
it was a beautiful thought

I felt I was drinking fresh water –
from the well near the apricot tree
and felt my young lips kissing the air around the edges of the glass –
...
What was that thing I was telling you.

She remains silent for a longer time –
reflecting what she had in mind that made her feel young again.
I dare not remind her.

Rain stops dripping now,
summer dryness enters the room,
and thirst overwhelms her.

She wants to go to the well to drink taza water –
with her weak knees,
she pushes herself and crawls toward the stairs.

 Then I must go to the farm
She now reaches the stairs.

 The well is not there, I say.
 It was in the grand house of yours,
 and we are not there anymore.

The well. The husband. The young time. The dreams.
The tomatoes. And her thirst is forty years in the past.

Her mouth is now half-open,
the wrinkles of her old age gather around her toothless mouth.
She is trying very hard to weep.

 But he calls for me
 I'm outside, I'm beautiful
 in the glow of the morning sunshine
 and I pick the last fresh tomatoes from the garden
 I hear him calling me,
 I run toward him and only see his handsome face...

She says it over and over,
until the sun sets when everyone goes to sleep
and dreams bring him to her.

TWO GRAVESTONES

We drove up to the hills of Karte-Sakhi –
ripping through the opened gate, the clouds disappeared
in the evening glow.

The blue mosque in the distance, unmoving;
the sleeping bodies smiled with the teasing of the dust.
My brown scarf flew above the gravestones in the yard.

We met my grandmother in her grave,
peacefully resting under the clay.
My eyes searching for her hands.

I knocked on her stone,
three times –
saying my prayers.

All her life, she knew one love.
One man. And one dream.
For each, I prayed.

First she herded her parents' sheep –
then she herded her husband's sheep.
I thought to myself.

My mother's hand rested on my shoulder,
'it is where everyone goes,
and we shall join Nanai Shaer,' she said.

My four-year old sister Azada had given my grandmother that nickname –
Nanai Shaer *grandmother lion* –
we call her around my house.

In old age, her face had become bigger
and her body much thinner.
She had the stern look of a lion.

Lately she would sit in corner,
like an old lion.
Quiet, but waiting.

And now like a sleeping lion, she lay there –
no longer waiting.
Without the need to speak

about her one love, one man and one dream.
Left for another woman at 32,
she remained faithful to one man until her death at 83.

Now the stars shine above her head –
the same stars shine for my grandfather,
resting a few graves to the north.

At last, she might meet him in this shared ground,
to see his face,
under the stars, in their lonely dark nights together.

And perhaps, as I wish,
he will give her another red ruby ring,
so that her one dream becomes numerous.

THE EMERALD RING

My little Grandmother Neek Bakht
Good Fortune wears colorful rings.

She is my maternal step-grandmother.
Mother of six daughters and four sons.

Last summer she gave me a gift,
her giant emerald ring.

'Green represents good fortune,' she said,
as she slipped the ring from her finger and onto mine.

It sat quietly on my young finger.
On hers, it had danced with an incandescent blaze.

Later, in the candlelight of evening,
I asked about the emerald ring.

'Tell me the story of the ring.' I said.
Instead *Good Fortune* told me a long-held secret.

Pain she had never shared.
Five stillborn children she had never spoken of.

'Not even to your grandfather.'
'My silence kept me from shame and disgrace,' she said.

I understood her.
Miscarriage is a woman's guilt and discussing it taboo.

A woman's pregnancy proves her 'Fruitfulness'.
Evidence of the 'Grace of God'.

Her ten successful pregnancies
could not erase the stigma she still carried.

Then she said, 'a woman is *red-faced* and her fortune is
emerald-green with her education and learning.'

And then I understood.
My education was my good fortune.

The ring was my grandmother's way of telling me,
I do not need to live the life of a traditional Afghan woman.

And everyday, when light catches my emerald ring,
I am reminded of both the joy and the responsibility of my good fortune.

I remember an effervescent young woman.
Every time I visited
she would fill the pockets of my coat
with dried apricots, mulberries, and almonds.

The most educated girl in her family,
she had passed her sixth-grade education
and grown up on Kabul University Road.
She loved poetry.

She wore the mini-skirts and socks of the time.
The youngest of her five siblings,
she was also the bravest. She spoke against
her father's second marriage.

Her fate was sealed when
my Grandfather *Grass* fled Kabul
with his two wives, *Lion* and *Good Fortune*,
four sons, and seven daughters,

and returned to the family's village in Ghazni.
My mother's sister, Sediqa,
was the only unmarried child from the first wife,
and the oldest remaining daughter.

*

I remember her subdued face
in her white wedding dress.
Her dark brown hair in the shape of a crown,
the mirror image of my mother.

Grandfather *Grass* hatched a master plan.
He would arrange a marriage for his daughter
and then send Grandmother *Lion* to Iran, to her sons.
His plan was successful.

Once in the village, where life was lived between
the feet of cows and the men wearing
rifles on their shoulders,
Sediqa was forcibly married off to a man,

who knew only of cows and goats.
'And her marriage to this man was a punishment.'
My mother says the same words –
every time he insults her in public.

*

I remember, at the time of her marriage,
Sediqa couldn't say a word. People saw it as
her defeat and danced with their scarves
running across their faces.

In this time and in the years that came after, she was silent
but not deaf. The music of the mud-river,
the singing of moth-butterflies, and the memory of
grandmother *Lion*'s tears gave life to her poetry.

In the stalls, in herding, she quietly wrote of her
and her mother's hardship.
She remained quiet for years.
Then she returned to Kabul.

She was reunited with Grandmother *Lion*
after fifteen years. She read her poems.

Grandmother *Lion*, despite her faded memory,
cried tears like the waterfall.

I did not understand why Grandmother *Lion* was crying,
but she must have been thinking of the poet
her daughter had been in her childhood.
But what use is the memory that cannot speak?

*

I remember, I met Sediqa again too.
Once again, she filled my pockets
with dried fruits, but this time she also put in
a letter for me to read to my mother.

Her letter was a poem that
whispered of her invisible wounds,
and the healing that came to her
from seeing my mother.

She had been quiet all this time.
For they had advised her:
'put a rock in between your teeth and don't
let it fall, otherwise you will be punished.'

Writing poetry, no one could punish her.
The rock did not fall. Her illiterate husband
did not mind the papers. He was not aware that he was
the fuel for the fire raging within her.

Now, Sediqa writes her poems like
WhatsApp messages and shares them with her siblings.
Her poetry makes sense of the past.
As if she can heal herself and others only with words.

QUEEN OF SHEBA

A week before the occasion of my brother's wedding,
my father advises me to meet and greet my female cousin,
who lives in the far-away city of Ghazni.

He asks me to share a little warmth from my heart with her.
Despite my reluctance for such a strange meeting with my cousin,
who is known for her 'illicit' deeds,
I nod anxiously.

What to say to my father's request,
he whose entire life has been devoted to
his family's needs and our well-being.

During the ceremonies surrounding my brother's wedding,
my friendly attitude to all is essential
in order to gain the praise of the women in the family—
no matter what the circumstances are.

The arrangements are made. I will receive my cousin,
whom I have not met since our early childhood,
and I will have a good time with her.

*

The wedding time comes closer.
Every member of the family is engaged with different tasks
from pressing the groom's clothing to cleaning his room.

I am given responsibility to cook the meals, clean the yard,
welcome the guests from far places,
arrange clothes for the other members of my family,

feed the children, and take care of all the other little tasks
that are part of life in the midst of a chaotic wedding week.

<p style="text-align:center">*</p>

The day before the wedding finally arrives.
Near to the mid-day sun, my cousin comes unaccompanied,
which speaks to the dilemma in her life.

My mother goes to her and, with full respect,
gives her a full and warm welcome.
Mother takes her to the guest-room, and then
asks me to be courteous and welcome my cousin, graciously.

I still do not know what to make of my cousin.
She seemed hollowed out by the village and the city,
and what is said of dignity or immoral fame.

I turn to my mother, thinking that she might understand
my hesitation about my cousin's visit.

Instead my mother says, 'Please come inside, Belqees *Queen of Sheba*
would love to see you after such a long time.
The first time she saw you, you were only five.
Now you've grown up, and she is eager to see what you look like.'

She then adds a last sentence.
'Even though you do not like her, you cannot distance yourself from her.'
My mother speaks the truth.
I still have to call her cousin, my father's niece.

<p style="text-align:center">*</p>

I go to my room next to the kitchen and change into
a gray skirt and rest a brown hijab over my head.

I walk toward the door, measuring the pace of my steps,
and thinking, what if it does not turn out to be okay?
What will my father think of his daughter?

Will he be disappointed to have such a coward for his daughter,
a daughter who cannot absolve her cousin of a mistake?

I whisper my common prayers, sounding to myself like
a sneak crawling unwittingly with some hushed murmurs.

Unexpectedly, I confront my father's gaze,
who to my surprise seems equally hesitant to walk into the room.
'Shall we walk together?' I suggest. We walk in.

 *

In the huge room, a little woman is sitting in a corner
with three children around her.
'Salam, dear cousin' are the first words my cousin says.
With a smile, I reply, 'Salam.'

I hesitate to hug her or give her a kiss or even to shake hands.
And my cousin understands why.

The children are one boy with narrow hazel eyes and two shy girls
with amber hair. 'What are their names?' I ask.
'*Wise Man, Wise Woman*, and *Basil*' my cousin replies.

'Are they your children?' I ask. Something pinches inside me
to tell me that was the wrong question, and in that question,
I have asserted the bitter judgment about my cousin's character.

She knows that I must have known that
she has only one son. She became pregnant before marriage
with a man, who had no former connection to
or future recognition within her family.

Everyone knew it.
Even I in the far land of America heard
about my cousin's 'illicit relationship' with a much older man.

She married him after she bore him a son.
They said the man was a member of the local Taliban,
who killed and detained other girls who denied him and other men like him.

Girls like my cousin became the scapegoats of the old regime
and the city. My question was justifiably exempted
with a mutual brief smile.

'I am kidding,' I say.
'They look so much alike, that's why I thought they could be siblings.'

'Yes, *Wise Man* is my own son.
And they are my sisters,' she responds as she points to the two girls.

'Your son is a fine-looking boy and your sisters are very beautiful,'
I hesitantly say with a smile that
made my teeth feel exhausted in my mouth.

'Yes, everyone says that they look so much like you, Parwana,
and their honorable uncle,' she responds to me,
as she gazes at my father.

I look up at my father, who is looking down at the floor.
He has not even said the word hello to his niece.
How am I supposed to keep my promise

if my father does not have the desire to speak a word to my cousin,
who is a sign of shame in the family?

*

'Father, do you want a cup of tea?' I ask.
'Yes, please, my dear daughter.'
I really do not want to hear the last part, 'dear daughter!'

I pour the tea in a cup and trying to settle
like the color of the tea, I present it to my father.
Through our gazes, we try to forgive one another.

And nothing more is said in our silent looks.
My mother is still sitting and behaving very well.
Always, she stays respectful to others.
How could I ever be the same?

*

Eventually, I relaxed:
I was not obliged to behave nicely with my cousin,
whose situation has been influenced

by the circumstances created by the Taliban
as have most of the women
who have lived through that fanatical era.

Yet the truth unfolds where I am a complete stranger,
my education and my experiences
defining me differently.

She resembles the image of a woman,
whom I encounter in my fears,
a woman I might have become if I had never left Afghanistan.

She grew up in such a fearful place and time,
a place and time that transformed women into rats
and left them nameless and without maps in the time of mercy.

And she is not to be blamed for not understanding me
and neither should I be blamed for sounding so merciless toward her.
Her courage is not to be questioned either.

Indeed, I believe that her survival is still a sign of courage –
a mouth-pressing response to the extremist regime
that ruled her city

and which left most of the women half-disappeared.

<div align="center">*</div>

I know that my cousin also finds me astonishingly mysterious.
Despite my cousin's nice words,
she left for the village and started talking about me

as her 'educated cousin,' with my shallow mannerism
of not greeting and talking with her properly.
Woman after woman who visit the city from the village

and encounter me now do not seem to understand me.
Is this because I cannot be like them?
Or is that I do not find a need to intermingle with such women?

Is it because I had the option
to become an educated, independent woman?
Do these women think I am dangerous?

Do they think I judge them unfairly?

*

I keep thinking about how the women of
some households have failed one another,

of the brutal history that
women have faced in parts of the world like Afghanistan,
where women exist in corners and no one sees

each other's growth or understands the choices each person makes.
In the lonesomeness and harshness of adolescence,
as women, we grew imbalanced, inadequate, and unalike.

And the truth is that no one is to be blamed;
neither this woman, nor those women, nor me.

*

History pays visits to women in this way.
The women who face the severest tests appear anonymous
and are judged the loudest in history.

History has ungraciously failed the women of my family as well.

GOLDEN-HAIRED ZARI

We met for the first and last time at a family wedding.
I was ten and she must have been twenty-five.

She danced all through the evening.
Under her high heels, the maroon-colored carpet also danced.

Her long hair was golden in color and her pink dress
shimmered under the yellow glow of lightbulbs.

My mother was equally mesmerized by my distant cousin's
beauty and freedom. We watched her walk from one corner to another.

At times, she spoke a different language.
Now I know it was English.

*

A few months later, news spread about a girl
kidnapped by a man. He made her his wife.

She was taken to a mountain hut.
There she had to cook and care for the husband.

The husband was in a gangster band.
The story spread. He had guns and men.

In the faraway mountains, he kept his wife to himself.
He would not let her go.

Some even said, the husband trained a tiger to keep watch over her.
News upon news, I let it slip like a feather.

I heard women in the neighborhood
speak about the beauty of the young woman.

'Zari zari bood. *Gold was like gold,*' they said.
The name and the beauty they described were familiar.

I asked my mother and she confirmed.
Yes, she was the golden-haired woman who danced

all through the evening. It was that Zari
we had admired.

'A woman's beauty is like a plague.'
'Her beauty will bring evil,' women said.

I listened to them.
I thought the story ended there.

*

A few weeks later, the rest of the news came
in the local newsletter.

In a picture, there were
four dead bodies lying outside the court-house.

In the black and white photograph, the color
of blood was the darkest.

I looked at those sleeping
bodies. I could recognize

those were two women with their
head scarves, now thrown beside their bodies.

And two men in white had fallen next to them.
The story was reported in Urdu.

I could hardly read it.
But then my mother explained.

That one is Zari. The woman next to her
is Zari's mother. The man is Zari's father.

The younger man is Zari's brother.
They were all killed because of Zari.

Millions of questions muddled my head.
Why was Zari dead? Why there?

Why the entire family? No one could answer me.
I thought the story ended there.

*

At the age of ten. I could tell the difference between
a river and a stream. My father loved me.

After Zari's death, my father, like every father,
stopped expressing his love to me, his eldest daughter.

Young girls like myself were left in a corner
without any explanation for the sudden turn of love.

And the mothers did the same.
I thought I had grown up and that was it.

To be loved and cared for was for the younger kids,
and only for the boys. So, I accepted it.

*

I did not know then that Zari's story had become a lesson
to the fathers and mothers of young girls in our family.

Zari was an overindulged girl.
Her parents had spoiled her.

They loved her, so they supported her decision,
to divorce the man who had made her his wife.

In support of the daughter, her parents
and the brother took the case to court.

The husband knew
she would not love him anymore.

So he stopped at the entrance of the court house with a gun,
and shot the entire family dead.

The husband retreated back into the mountains.
'He is a powerful man. With money and guards.

They could never capture him.
She should have just stayed with him.

If she had done so, the parents and the brother
would have been alive now.'

This ending to the story survived
for as long as it could – as a moral.

*

No one ever wanted to know
what the real story was.

Zari was killed and so was her story and her demand for justice.
Instead a wrong moral remained for her relatives.

Do not spoil your daughters.
Do not give them too much love and attention.

No girl should think to become a Zari,
neither for good nor bad.

I was defeated from the time I learned
the reason for Zari's death.

Since then she has lived in me as a wrong caution.
Where are husbands like Zari's.

I should not be a Zari myself.
I lshould love and care about my parents and my brothers.

But a man's side of the story is never misjudged or erased.
For a man is without flaws, they say.

I wondered if Zari would ever be considered without flaw.
I remember I asked myself when I turned twenty-five.

But by then Zari was dead for fifteen years.
I had finished studying at Stanford and she

remained stuck between the depth of earth and its surface,
between what society decreed as her faults and his judgment.

How was fate at work in this?
I remember I asked myself when I saw the photos.

FORTY NAMES

FORTY NAMES

I

Zib was young.
Her youth was all she cared for.
These mountains were her cots
the wind her wings, and those pebbles were her friends.
Their clay hut, a hut for all the eight women,
and her Father, a shepherd.

He knew every cave and all possible ponds.
He took her to herd with him,
as the youngest daughter
Zib marched with her father.
She learnt the ways to the caves and the ponds.

Young women gathered there for water, the young
girls with the bright dresses, their green
eyes were the muses.

Behind those mountains
she dug a deep hole,
storing a pile of pebbles.

II

The daffodils
never grew here before,
but what is this yellow sea up high on the hills?

A line of some blue wildflowers.
In a lane toward the pile of tumbleweeds
all the houses for the cicadas,

all your neighbors.
And the eagle roars in the distance,
have you met them yet?

The sky above, through the opaque skin of
your dust, carries whims from the mountains,
it brings me a story.
The story of forty young bodies.

III

A knock,
father opened the door.
There stood the fathers,
the mothers' faces startled.
All the daughters standing behind them.
In the pit of dark night,
their yellow and turquoise colors
lining the sky.

'Zibon, my daughter,
take them to the cave.'
She was handed a lantern;
she took the way.
Behind her a herd of colors flowing.
The night was slow,
the sound of their footsteps a solo music of a mystic.

Names:
Sediqa, Hakima, Roqia,
Firoza, Lilia, Soghra.
Shah Bakhat, Shah Dokht, Zamaroot,
Naznin, Gul Badan, Fatima, Fariba.
Sharifa, Marifa, Zinab, Fakhria, Shahparak, MahGol,

Latifa, Shukria, Khadija, Taj Begum, Kubra, Yaqoot,
Nadia, Zahra, Shima, Khadija, Farkhunda, Halima, Mahrokh, Nigina,
Maryam, Zarin, Zara, Zari, Zamin,
Zarina,

at last Zibon.

IV

No news. Neither drums nor flutes of
shepherds reached them, they
remained in the cave. Were
people gone?

Once in every night, an exhausting
tear dropped – heard from someone's mouth,
a whim. A total silence again.

Zib calmed them. Each daughter
crawled under her veil,
slowly the last throbs from the mill-house

also died.
No throbbing. No pond. No nights.
Silence became an exhausting noise.

V

Zib led the daughters to the mountains.

The view of the thrashing horses, the brown uniforms
all puzzled them. Imagined
the men snatching their skirts, they feared.

We will all meet in paradise,
with our honored faces
angels will greet us.

A wave of colors dived behind the mountains,
freedom was sought in their veils, their colors
flew with wind. Their bodies freed and slowly hit

the mountains. One by one, they rested. Women
figures covered the other side of the mountains.
Hairs tugged. Heads stilled. Their arms curved
beside their twisted legs.

These mountains became their cots.
The wind their wings, and those pebbles their friends.
Their rocky cave, a cave for all the forty women.
And their fathers and mothers disappeared.

In a village, where my parents lived with their children,
there was always a stream flowing –
clear as glass.

Some said: the stream was from
the glacier on the central mountains.
The elders advised the stream sprang from God's mercy.

The region around the stream also
sheltered white wolves.
They came from the northern regions, people said.

I watched the wolves become wilder in winter.
The chickens were kept inside the locked gates.
The men carried their guns.

The women repeatedly recited Surahs,
and the children wore their prayer amulets
around their necks.

*

There was a famous fable about this village
that was told to children in winter.

Many years ago, there was a woman.
Her name was Bakhti,
she did not fear to walk outside alone in the cold night.

She was found one dawn, paralyzed,
her body half white and half black.
The villagers said.

'It was certainly a ghost.'
'She was cursed'. 'She saw the wolves.'
A giant white wolf was found, lifeless next to her.

The woman had wrapped her scarf,
like a bridle around the neck of the wolf, and rode
all night, like one rides a horse, into the mountains.

Both were exhausted from their long ride.
The wolf died before the sunrise.
The woman died two days later.

After her death, the village came to be known as,
Bakhti-Gurgi, the *wolf-Bakhti's* village.
The villagers said, 'Bakhti became a wolf.'

*

Each winter, my mother would tell me this story.
'Did Bakhati really become a wolf?' I asked as a child.
'No, she killed the wolf,' my mother replied.

One winter, when I was older, I understood.
Bakhti had met a wolf that night, in her yard, alone.

She did not scream.
She did not call to the men with guns. Instead,
she died daring to be brave.

One red autumn evening, she came to our village.
'She is a wolf,' men said, grabbing their shotguns.
'She is a fox,' women said, rushing toward their chicken-huts.

Through the window, I could see
the centuries-old graveyard,
that night someone had left two candles lit.

'The wolves have come to our village, we need to hurry,'
a hand pulled me away from the window.

Everyone sat together,
reciting *Surahs* from the Quran.
I sat next to my mother, in anticipation.

Mothers put their children to bed.
Men sat with shotguns resting on their arm.
I refused to sleep, watching from the window.

Then a song came from between
the watermelon grounds and the apricot trees.
I hurried back to the window.

There I saw a woman.
Her wrinkled Chador had fallen off her shoulders.
Her face illuminated by the candlelight.

She walked toward me, close enough so I could see
the motion of her feet beneath her dress.
She sang and laughed. Then she disappeared.

Years later, remembering that night, I asked my mother,
'who was this woman who sang me poetry,'
with cadences that captivated me.

She was Durrani, my mother said.
A Pashtun woman, who dishonored her family
by falling in love with a Hazara man from our village.

At night she found solace in our village, but only those nights,
lit by candles left in the cemetery,
by her forbidden love.

IN SEARCH OF A WOMAN

HER NAME IS FLOWER SAP

Somewhere – in the no-man's land,
there are high mountains, and there is a woman.

The mountains are seemingly unreachable.
The woman in her anonymity is untraceable.

The mountains are called the Tora Bora.
The woman is known as Sharbet Gula, *Flower Sap*.

In her faded-ruby-red Chador, she appeared
a young girl with a frown, with her green eyes.

Not knowing where to look.
When the world looked back at her.

As young kids, refugees of wartime in Pakistan
we were equally intrigued with her photograph.

'Her eyes have the magic of good and bad.'
'The light of her eyes can destroy fighter jets.'

So went Afghan children's conversation
in the aftermath of 9/11. 'But could she take down

The Taliban jets,' we wondered,
as the jets crossed the skies in one song.

But *Flower Sap* could never answer us.
For she had disappeared like our childhood.

*

As the borders became damper lands,
Afghans like soft worms crawled toward their homeland.

In the in-between mountains,
Flower Sap re-appeared, without any answers.

Now she was a grown-up woman.
A mother of four girls. A widow.

There were some questions in her eyes.
The ones I had seen in my parents' eyes.

Where do we go next? Now that our country is free.
She still did not have any answers.

And where was the power of her eyes?
I then saw her smiling. As an immigrant, I smiled too.

For her name saved the day.
She was taken to a hospital for her eyes.

The president of the county met her,
and sent her on a pilgrimage.

Her name educated her daughters,
it gave her a house and a reason to return to her homeland.

What else is there in the names and naming?
If not for reparation.

THE FLOWER IN THE PEAR

It was a younger time.
My homeland was now a new-land.
We were refugees, and so were all
the neighbors, who were equally good people.

But in our school for refugee kids,
there was the most hated young woman.
Tall, dark hair, high cheekbones, and noble bearing.
Her name was Adeela, *Just-Woman*.

Students learned from their teachers to avoid her.
To leave her unaccompanied.
I remember how our Ethics teacher would caution us
about *Just-Woman's* unacceptable choices.

I never understood the reason for such hatred.
As one of the youngest, and most probably
the simplest girls in the class, I befriended *Just-Woman*.
We sat together.

I shared my daily meal with her.
One time *Just-Woman* showed me the flower that
resides deep in the heart of a pear,
if sliced through just so.

We walked home together, through the lonely streets.
One day, she paused and indicated she would take a different path.
'I want to see my Ama Neloofar, *Aunt Lotus*,' she said.
We said our goodbyes.

But I was concerned. For what, I do not remember.
So I followed her quietly along the big road,
I crossed by a little sweet-shop and entered a narrow lane,
I kept following her.

I believe that she had no clue.
She entered a faded silver gate.
It led to the most deserted yard in the area.
I watched her through a small hole in the gate.

Like a cat she moved and slipped into
the ruined places. Her light blue dress faded
into the fallen clay walls.
She disappeared among them.

I found myself running faster than ever.
Back to where I said goodbye to *Just-Woman*.
I prayed to see her tomorrow.
I wanted to know where she went. For what.

But then the memory fades away.
I do not remember if she ever came back to school.
I asked everyone about *Just-Woman* and everywhere.
Not a single person remembers her.

But I know that for as long as the flower
inside the pear remains,
I will be reminded of her.
And perhaps she remembers me too.

THE CALLER AND HER CONSTELLATION

Nadia was her name.
She preferred Anjuman.
The *Caller* and the *Constellation* in a corner,
with an un-silenced congregation.

Her congregation named themselves the sewing circle.
In their midst, voices unheard found an audience.
In their midst, poetry sprung from their invisibility.
Outside, she was a prisoner.

In her solitude, she prayed in poetry.
Mediating with blue melody,
she entreated God to give her peace in her art.
Her own throat became a tunnel toward an upended light.

She knew of herself as a poet. In the pit
of the bluest nights screaming about
the bright spring days, where parties are on,
and poetry is allowed, instead of Kalashnikovs.

In their midst, she became the wisest of her time.
In her congregation, writing face-less-ly,
in the depth of her chest, with secrets and fears,
she mastered *Smoked Flower* and *Blue Memories*.

Her imaginative journeys were without maps
no rivers to cross, yet
piercing through the heart of history,
she was on top of her game in the most dangerous time.

Killed in her own home.
Trapped in-between the rage of her husband,
and the worst words of her mother-in-law,
even her poetry could not save her.

Was poetry to blame?
Regardless, her words gave life
to a new tradition among Afghan women poets
whose words are no longer prayers.

But hammers striking against the old order,
against the 'honour' of the wildest society.
Giving voices and names to members of the congregation,
a *Caller* and her *Constellation*.

READING NADIA WITH EAVAN

1

I come from a mountainous land,
the skirts of its valleys are filled with poppies.
Each one with a darkened heart,
resembling black-haired women –
visiting from some distant past.
Their eyes darker than the clothes
they have wrapped around their shy bodies.

They have their hands cupped around their ears,
to hear the orchestra of sounds inside their heads.
Not knowing they are the spectacles of their own show.

2

This land has long been silenced.
Only one woman allowed herself to hear and sing a song,
writing poetry by holding up a mirror,
and singing to her own reflection.

That woman was Nadia Anjuman.
A poet from Herat, Afghanistan,
she became the Afghan poet of her era –
the harshest of eras.

In 2005, she died a violent death –
at the hands of her husband.
News of her death
spread like red water on a white surface.

Yet, her brave voice could not be silenced.
It only grew in meaning.

3

Years later, reading Nadia with Eavan Boland
in my poetry session in Margaret Jacks Hall
I hold that mirror now.

I paint the woman I see in it.
The woman I paint is Nadia.
I paint her with the words I speak when
Eavan questions me:

What did Nadia mean when she wrote –
it is the green gaits of the rain that makes the sound…
What is her sense of the private
versus the public imagination?

I say:
Nadia was a visionary,
she was waiting for women poets
to rain on the land that had harvested them.
Nadia writes:
They reach here from the road, this time,
bringing a few thirsty souls…
[with] *their drying throat…*

She is making a promise.
The promise of a voice that will not die of thirst or unsatisfied.
A throat that echoes truth beyond
the designated spaces, be they private or public.

4

In the month of April, year 2020,
Eavan appears to me on the other side of the mirror,
in a place between a memory and a dream,
she holds my left arm and talks to me about poetry.

I hear her voice.
Again, she asks me about the meaning of Nadia's message.
Now I think I know the answer.

I respond:
Nadia's message was of the land through the light,
where the only country is ruled in-between
God and a woman's mind.
In there, God is the woman's voice.

It is midnight already.
I have now drawn the rain in the color of light,
the land in the color of golden reed-crops
that grow taller with their heads up high, piercing the light.

Nadia and Eavan, a mind and a voice,
I hear them speak, and they speak of truth
that is never irrational or outside history.
They are in their simplest form, like time.

THE WOMAN ON THE ROCK

It was a cold winter in Kabul, on my way to school,
I saw a young woman sitting on a rock. I stopped.
I stood there, watching her, both of us silent.

The woman did not move, like a marble statue, it seemed.
I had my physics exam.
I turned and walked inside the school gate.

The next day, I looked for the woman sitting on a rock.
I will invite her home to share my lunch, I thought.
But the woman was gone.

A few days later, news of a young woman's
dead body found behind our school.
What was her story, I wondered? To die in the cold, alone.

Each winter, in-between autumn and spring
I remember the woman. She comes and sits on that rock.
The hand of winter wraps around her.

Creeping in the middle of the night,
from across the plains and above the trees,
her unknown face, like the silent music of the snow, comes to me.

IN SEARCH OF A WOMAN

1

As morning melody breaks,
this city breathes in the middle of some dried dust.
Street vendors start by the river
selling all kind of drugs for the city.

This opaque people
smoking hashish.

Its once inky blue river twisted through the city.
It is now a broken river,
its banks darkened by trash of all kinds.

2

Once, after midday prayers,
women headed to the city's river
to wash their clothes, rubbing and pounding them
on its stones. Crossing the blue carpet of the river,
the sky was in the turquoise water,
a mirror, an immortal soul of the city.

3

Now after midday,
this riverbank is home for this opaque people.
As the Mughreb *evening* sunset fades out,
these men head to the mosques.

4

I search in the streets of Kabul for a woman.
Instead of writing poetry,
I search for her, inside and outside each room.
Where could she be at this time of the day?

5

Kabul now sleeps.
From the window of my house, I remain
in a room filled with women and children.

The odour of their clothes, the smell of the children,
over and over, the door is locked.
Looking for a transcendence to emerge,
or a memory to reside, each day is the same day.
I continue to write a poem.